# YOU CAN DRAW FANTASY FIGURES
# DRAWING MIGHTY RULERS

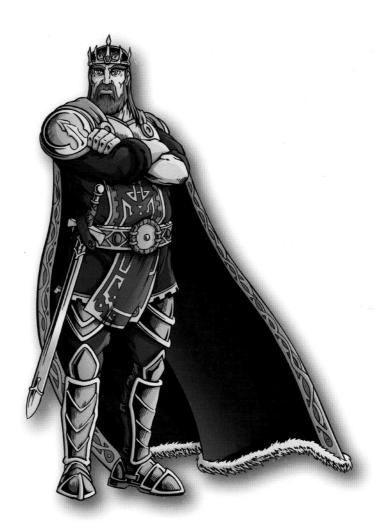

## BY STEVE SIMS

**Gareth Stevens**
Publishing

**Please visit our Web site, www.garethstevens.com. For a free color catalog of all our high-quality books, call toll free 1-800-542-2595 or fax 1-877-542-2596.**

Library of Congress Cataloging-in-Publication Data

Sims, Steve (Steve P.), 1980-
Drawing mighty rulers / Steve Sims.
    p. cm.—(You can draw fantasy figures)
Includes index.
ISBN 978-1-4339-4064-4 (library binding)
ISBN 978-1-4339-4065-1 (pbk.)
ISBN 978-1-4339-4066-8 (6-pack)
1.  Kings and rulers in art. 2.  Fantasy in art. 3.  Drawing—Technique.  I. Title.
NC825.K52S56 2010
743.4—dc22

                              2010015837

First Edition

Published in 2011 by
**Gareth Stevens Publishing**
111 East 14th Street, Suite 349
New York, NY 10003

Copyright © 2011 Arcturus Publishing

Artwork and Text: Steve Sims
Editors: Kate Overy and Joe Harris
Designer: Steve Flight

Printed in the United States of America

CPSIA compliance information: Batch #AS10GS: For further information contact Gareth Stevens, New York, New York at 1-800-542-2595.

SL001642US

# CONTENTS

# Drawing and Inking Tips

In the world of swords and sorcery, heroes can perform extraordinary feats of valor that would be impossible in the real world. However, it's still essential that your characters should look solid and believable. So here are some helpful hints to keep in mind.

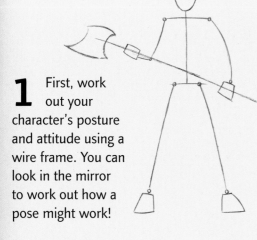

**1** First, work out your character's posture and attitude using a wire frame. You can look in the mirror to work out how a pose might work!

**2** Build on your frame using basic shapes such as cylinders and spheres. As you add them to your wire frame, you can start to see your figure taking shape. From there, draw a smooth outline around the shapes to flesh out your figure.

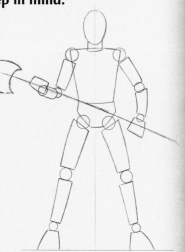

## TOP TIP!

Most adult human figures are seven times the height of their head. Draw your character's head, then calculate his or her height by measuring three heads for the legs, one for the lower torso, and two for the upper body.

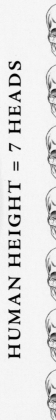

**HUMAN HEIGHT = 7 HEADS**

**3** When things are looking good and your character is complete, you can start to ink the picture. Inking allows us to choose the best lines we have drawn in pencil and make them stand out from the rest.

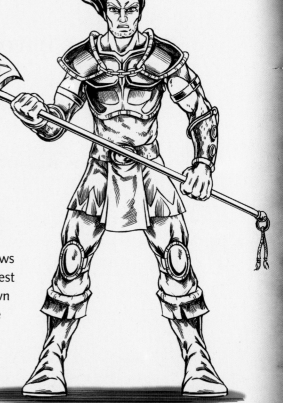

## Coloring Tips

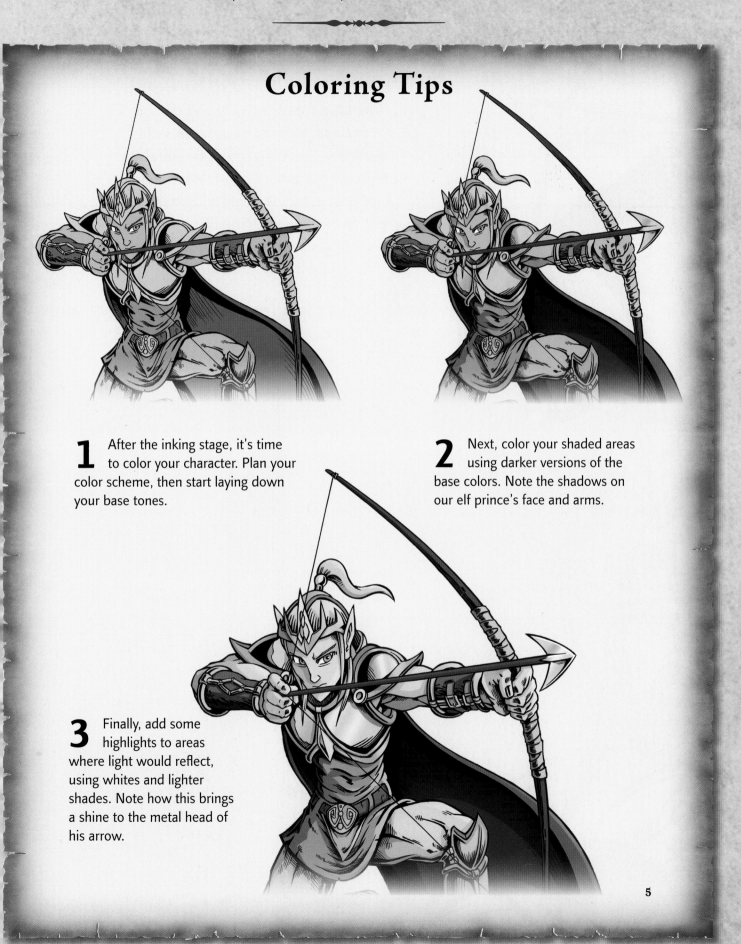

**1** After the inking stage, it's time to color your character. Plan your color scheme, then start laying down your base tones.

**2** Next, color your shaded areas using darker versions of the base colors. Note the shadows on our elf prince's face and arms.

**3** Finally, add some highlights to areas where light would reflect, using whites and lighter shades. Note how this brings a shine to the metal head of his arrow.

# KING

The king stands mighty and defiant against the oncoming hordes of darkness—an inspiration for all who fight on the side of good. Wise, kind, and true, he leads his people into battle, his presence instilling a sense of courage into those who fight alongside him.

**1** Start with a strong and sturdy pose for our all-powerful ruler. His legs should be straight and planted firmly on the ground.

**2** When filling out the frame, make his chest and shoulders big and strong to emphasize his royal power.

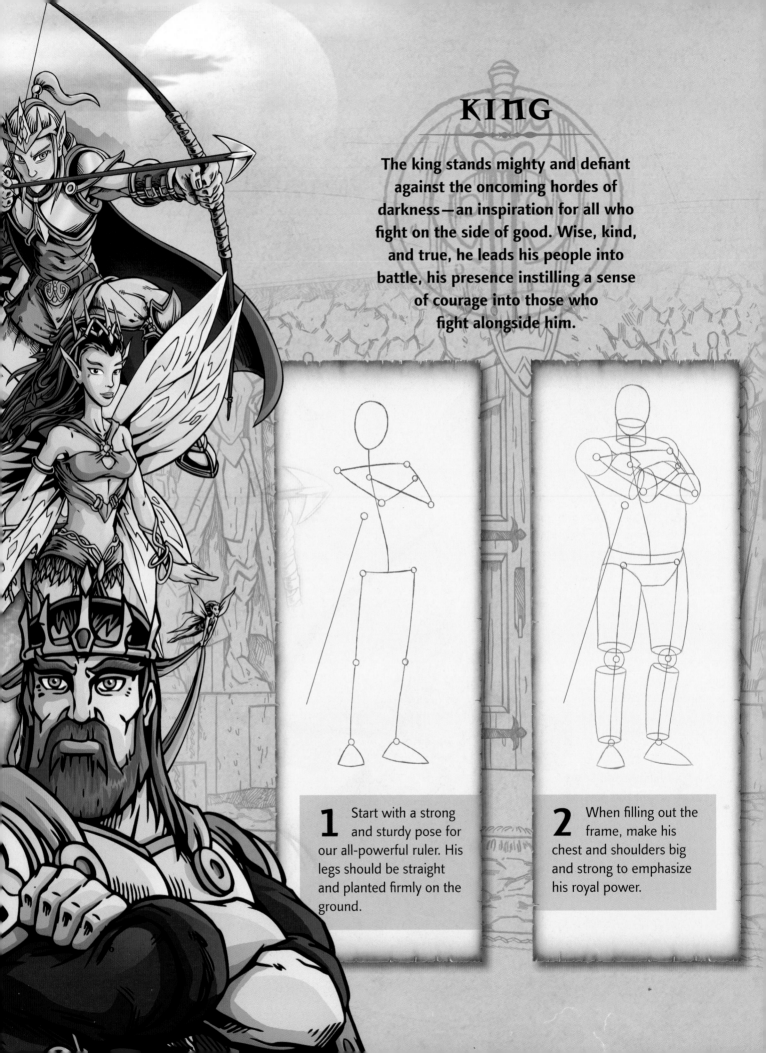

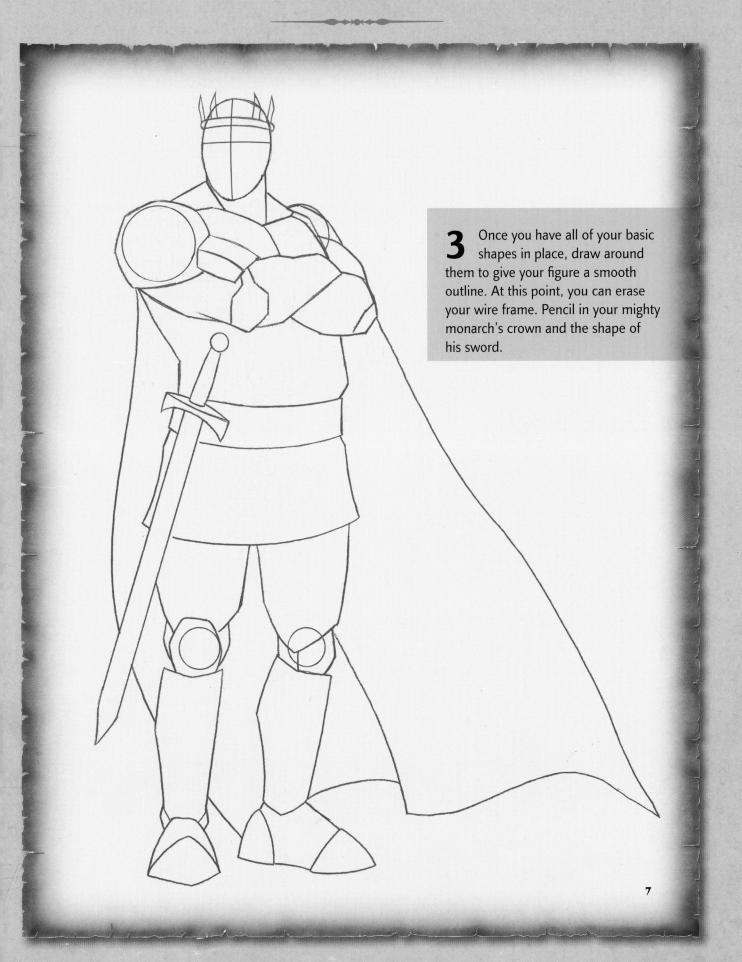

**3** Once you have all of your basic shapes in place, draw around them to give your figure a smooth outline. At this point, you can erase your wire frame. Pencil in your mighty monarch's crown and the shape of his sword.

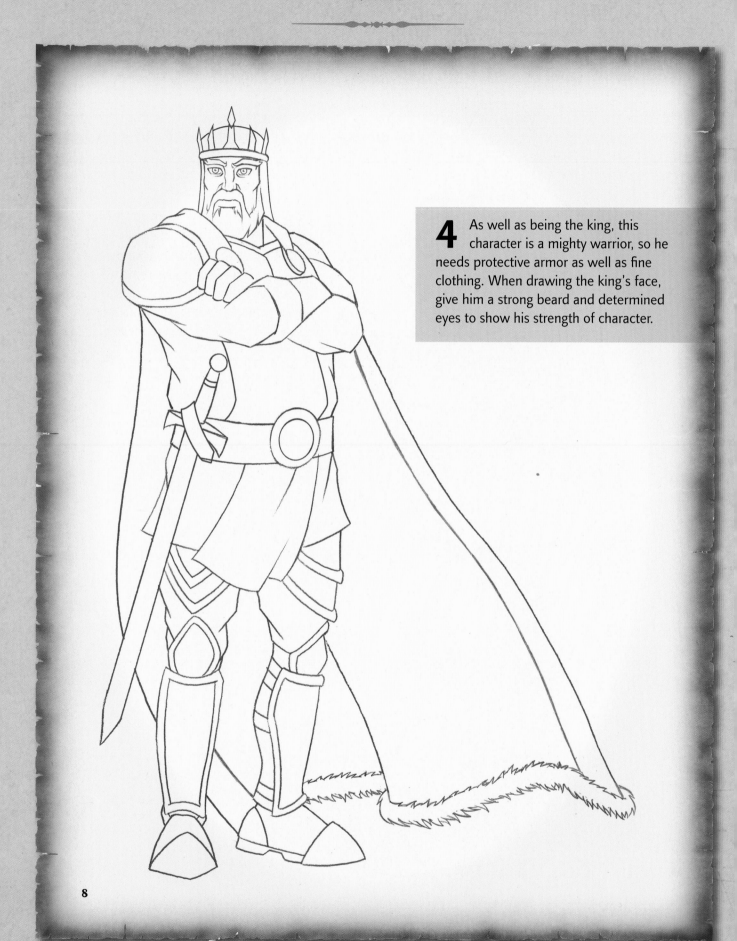

**4** As well as being the king, this character is a mighty warrior, so he needs protective armor as well as fine clothing. When drawing the king's face, give him a strong beard and determined eyes to show his strength of character.

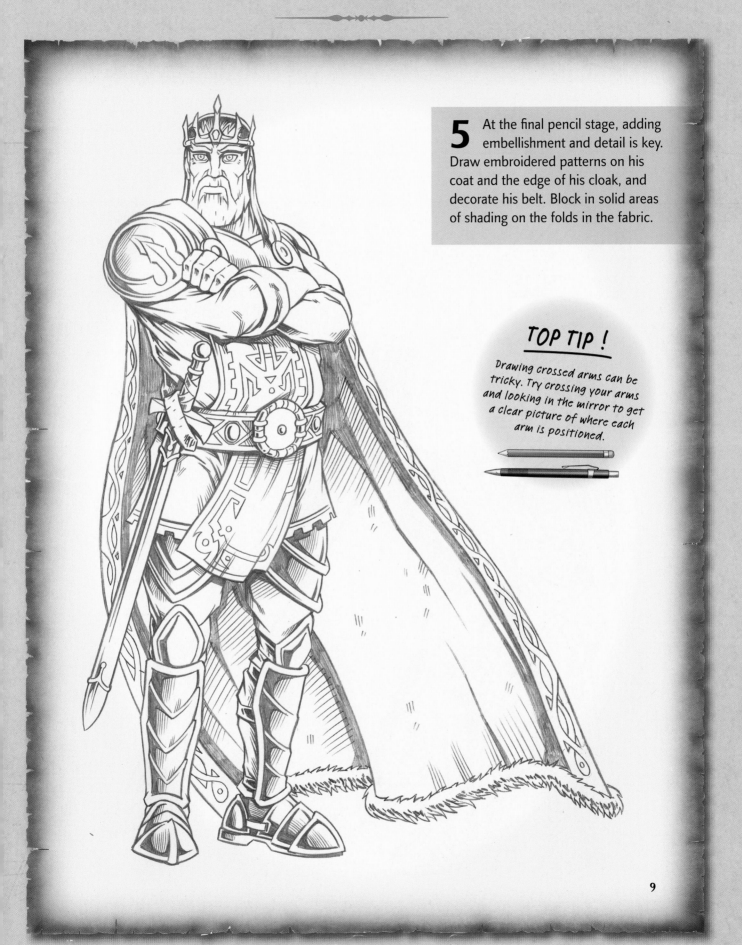

**5** At the final pencil stage, adding embellishment and detail is key. Draw embroidered patterns on his coat and the edge of his cloak, and decorate his belt. Block in solid areas of shading on the folds in the fabric.

## TOP TIP !

Drawing crossed arms can be tricky. Try crossing your arms and looking in the mirror to get a clear picture of where each arm is positioned.

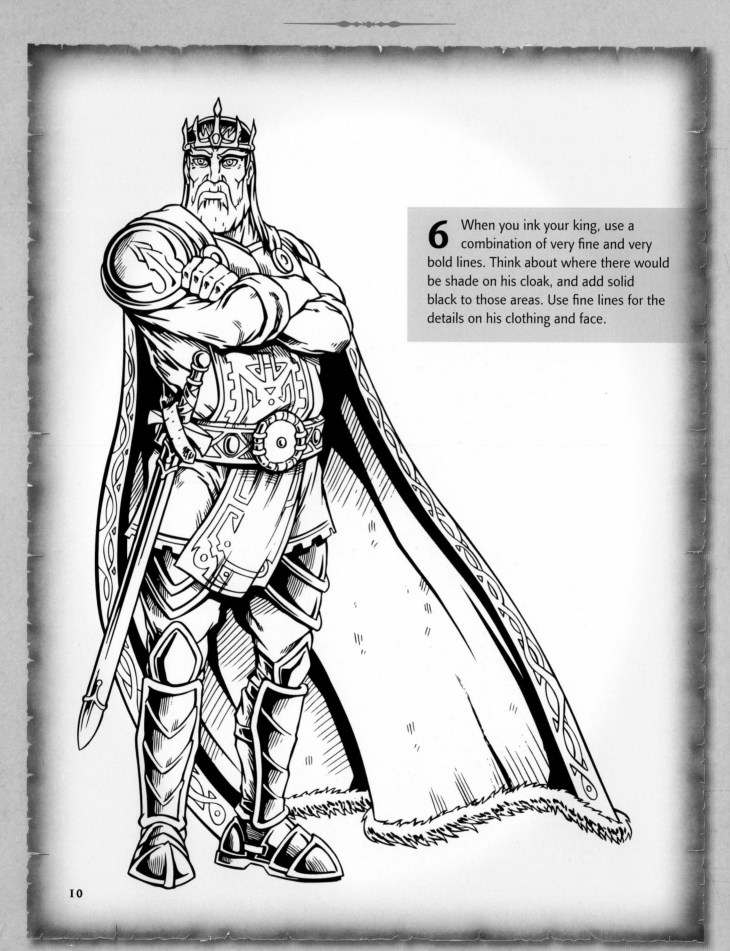

**6** When you ink your king, use a combination of very fine and very bold lines. Think about where there would be shade on his cloak, and add solid black to those areas. Use fine lines for the details on his clothing and face.

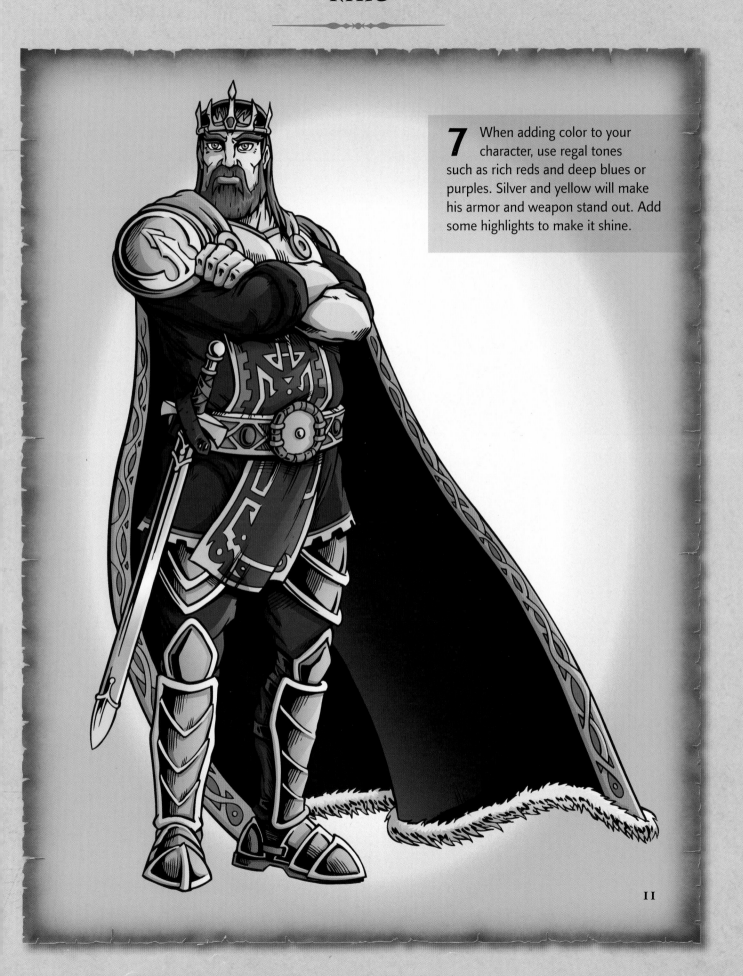

**7** When adding color to your character, use regal tones such as rich reds and deep blues or purples. Silver and yellow will make his armor and weapon stand out. Add some highlights to make it shine.

# FAIRY QUEEN

As ethereal and beautiful as the Land of Light itself, the fairy queen leads her people against the forces of darkness. She wields the mightiest of all powers—the power to control the natural elements. She can conjure a storm in seconds, and has fire at her fingertips.

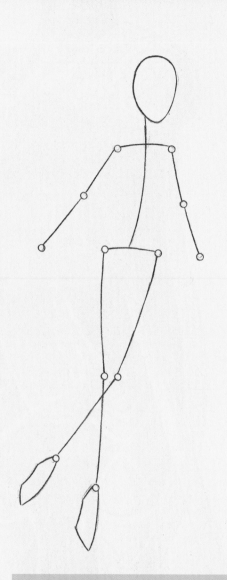

**1** Start by drawing the wire frame. Give your fairy queen a light, graceful posture. As she will be flying, her feet need to be pointing toward the floor, rather than resting flat on it.

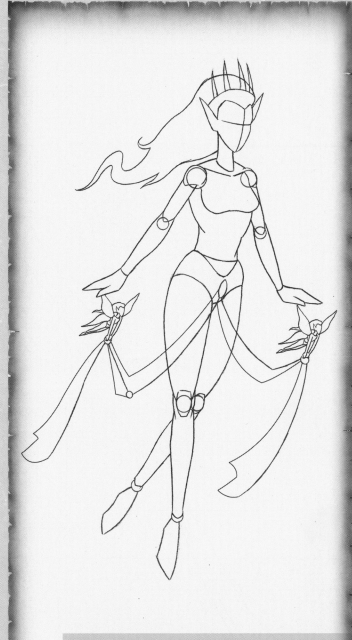

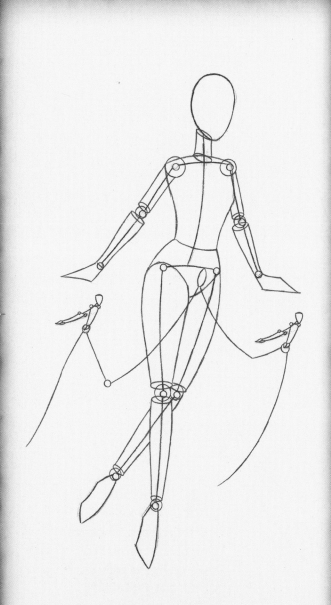

**2** Build on your frame with basic shapes, keeping the flow and curve of her feminine form. Start the basic framework for two tiny fairies that are holding her silken belt.

**3** Remove your wire frame and pencil in the outline of her body, hair, and crown. Develop the shape of the smaller fairies and the scarf they are holding.

13

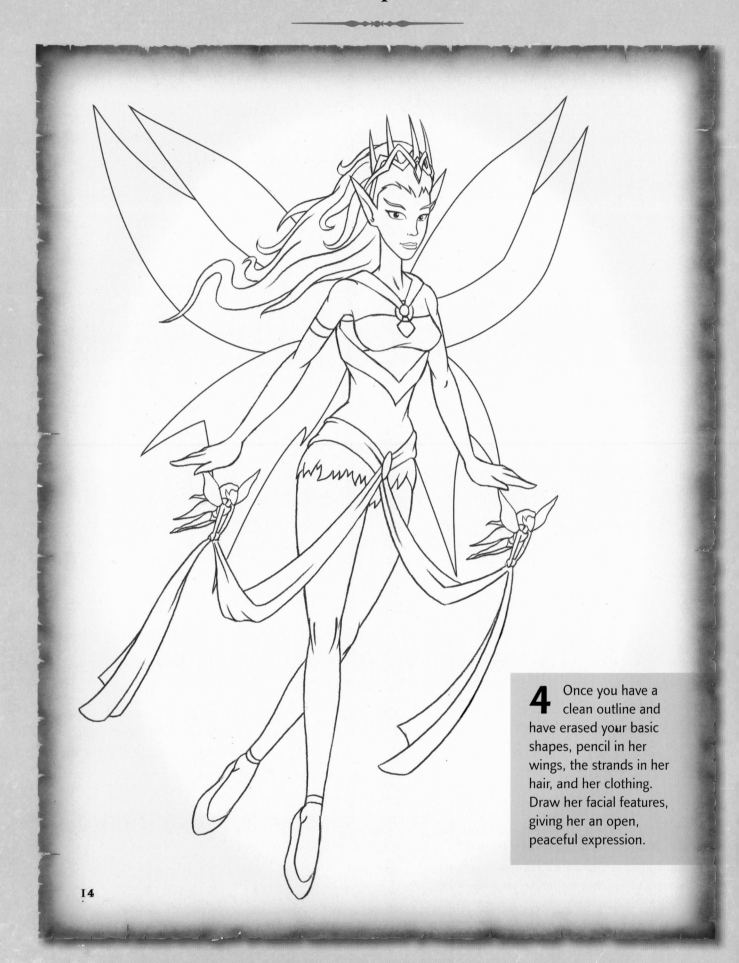

**4** Once you have a clean outline and have erased your basic shapes, pencil in her wings, the strands in her hair, and her clothing. Draw her facial features, giving her an open, peaceful expression.

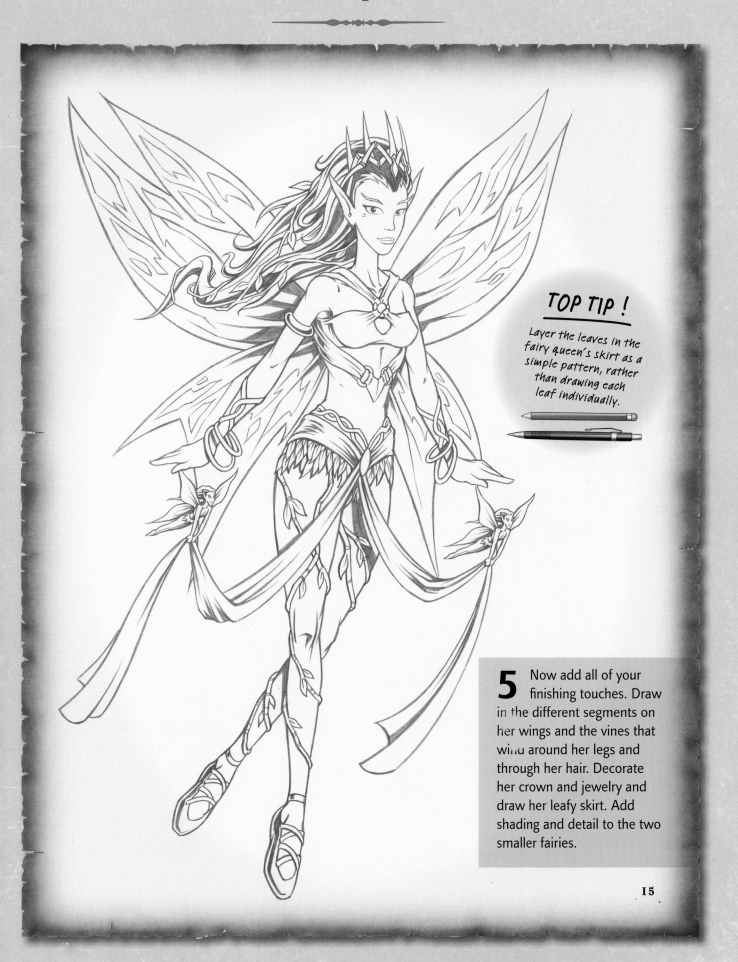

## TOP TIP !

Layer the leaves in the fairy queen's skirt as a simple pattern, rather than drawing each leaf individually.

**5** Now add all of your finishing touches. Draw in the different segments on her wings and the vines that wind around her legs and through her hair. Decorate her crown and jewelry and draw her leafy skirt. Add shading and detail to the two smaller fairies.

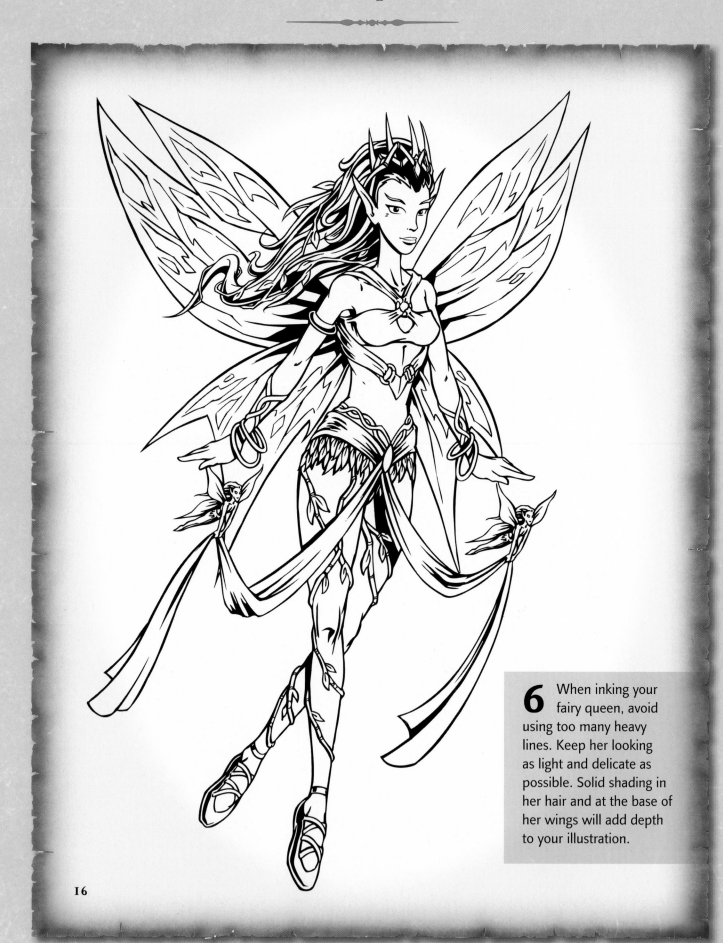

**6** When inking your fairy queen, avoid using too many heavy lines. Keep her looking as light and delicate as possible. Solid shading in her hair and at the base of her wings will add depth to your illustration.

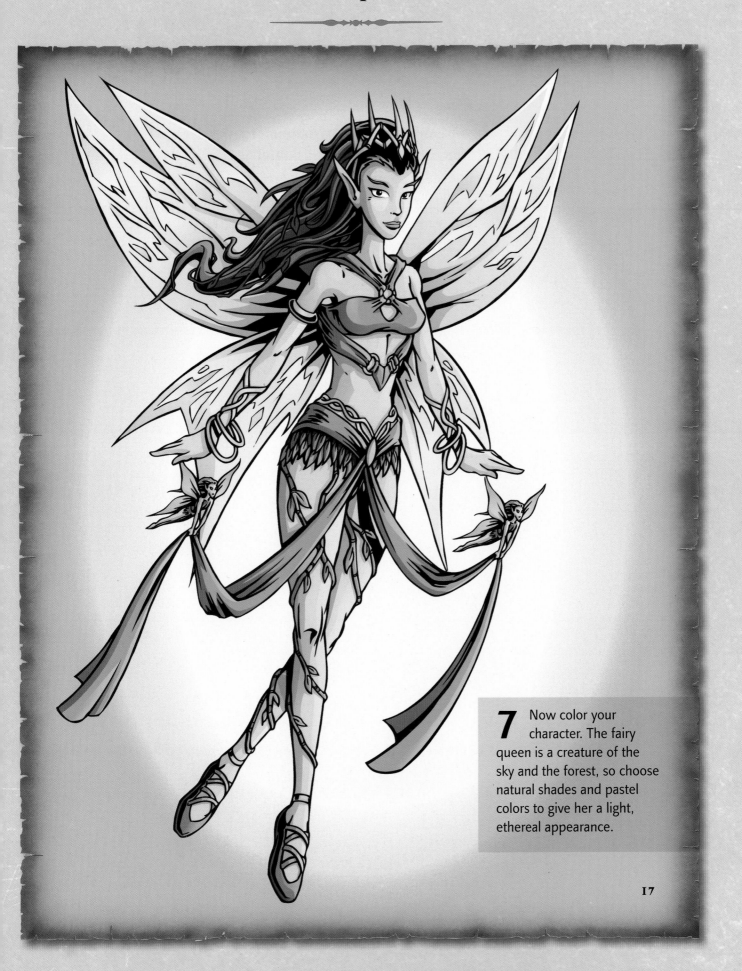

**7** Now color your character. The fairy queen is a creature of the sky and the forest, so choose natural shades and pastel colors to give her a light, ethereal appearance.

# ELF PRINCE

Though not as physically strong
and imposing as a barbarian or
an orc, this noble and skillful
fighter is every bit as dangerous.
He relies on his deadly accurate
aim, naturally heightened senses,
and athletic abilities to see
him through a battle.

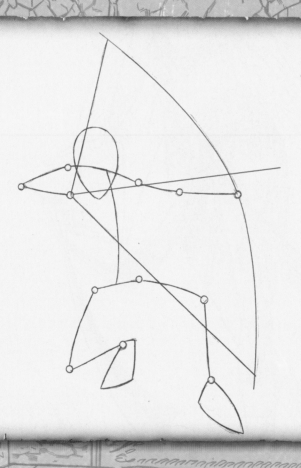

1 Start by drawing your prince's frame, adding the bow he is pulling back, ready to fire.

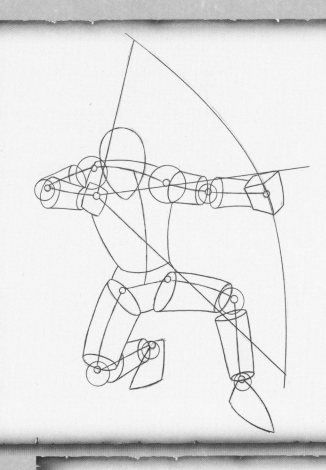

**2** Build on your frame using basic shapes. His left arm is stretched out in front, and will appear larger since it's farther forward.

**3** Fill out the body, then erase your construction shapes. Draw his elf ears, weapon, and clothing as you prepare your clean pencil drawing.

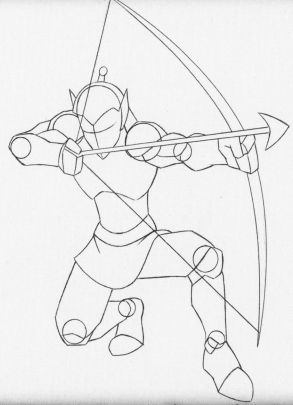

19

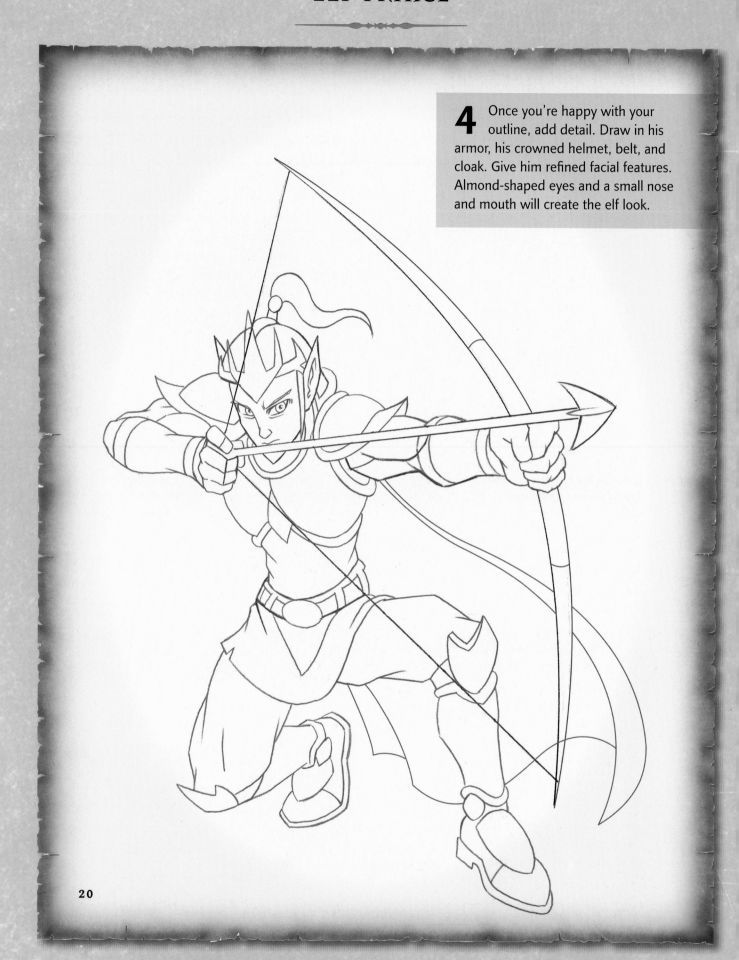

**4** Once you're happy with your outline, add detail. Draw in his armor, his crowned helmet, belt, and cloak. Give him refined facial features. Almond-shaped eyes and a small nose and mouth will create the elf look.

**5** Add plenty of shading to your final pencil drawing. The solid shaded areas will look very dramatic once they're inked in. Keep his outfit simple, but add decoration to his belt buckle and crown.

## TOP TIP !

Use foreshortening to give your drawing perspective and make it look three-dimensional. Draw objects that are farther away smaller than those closest to the front, like we've done with the elf's arms.

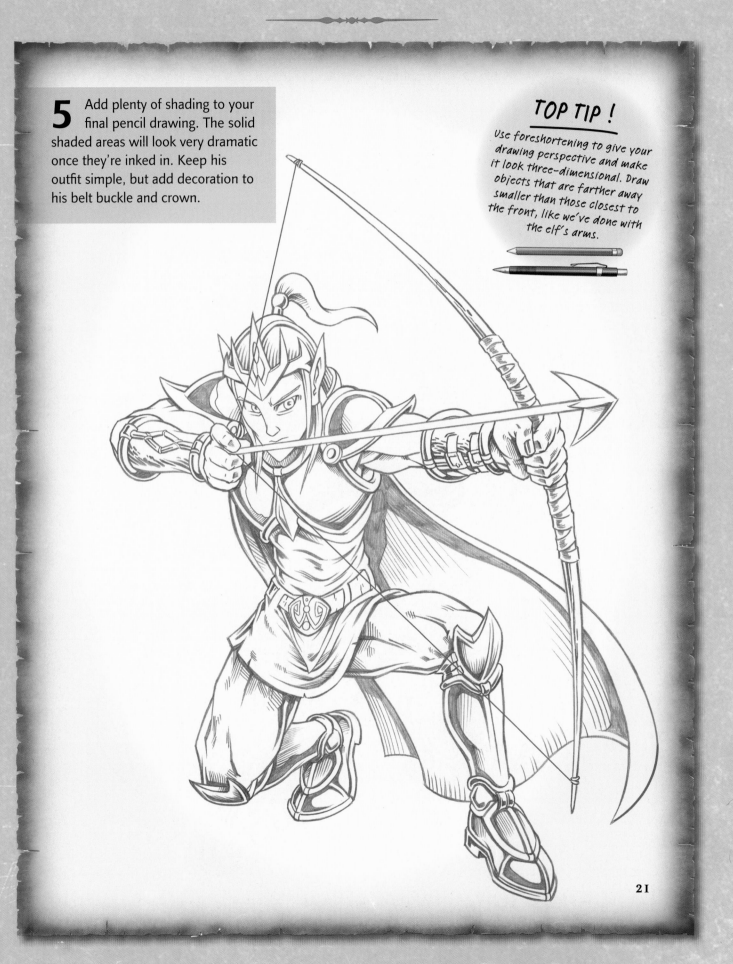

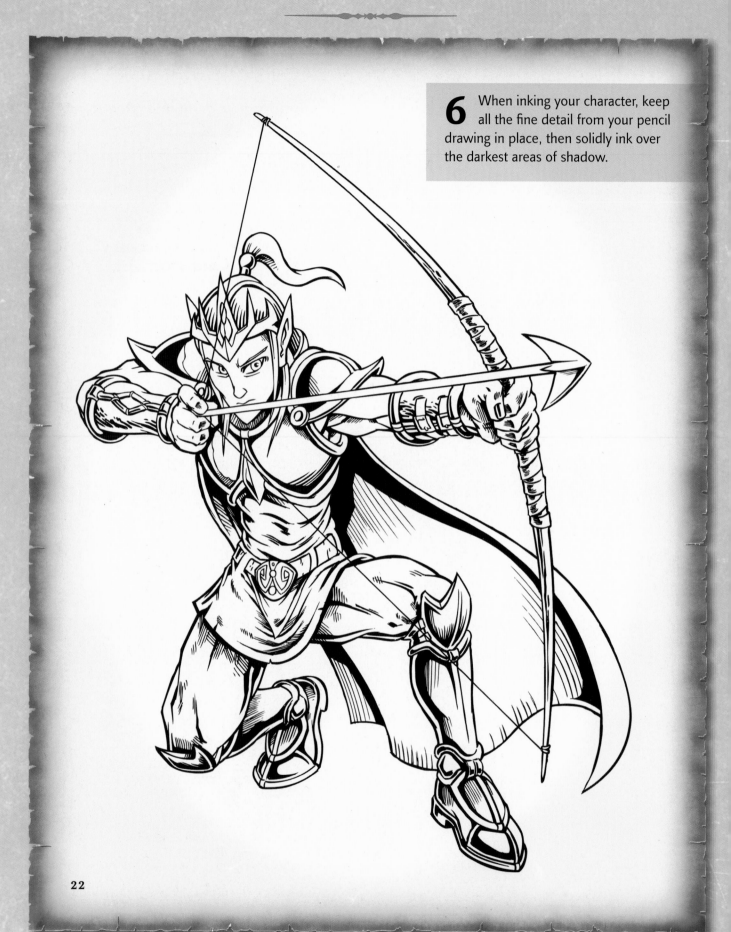

**6** When inking your character, keep all the fine detail from your pencil drawing in place, then solidly ink over the darkest areas of shadow.

**7** Finally, add color to your character. Shiny silver armor will give him a battle-ready look, and a dark green cloak will give him camouflage.

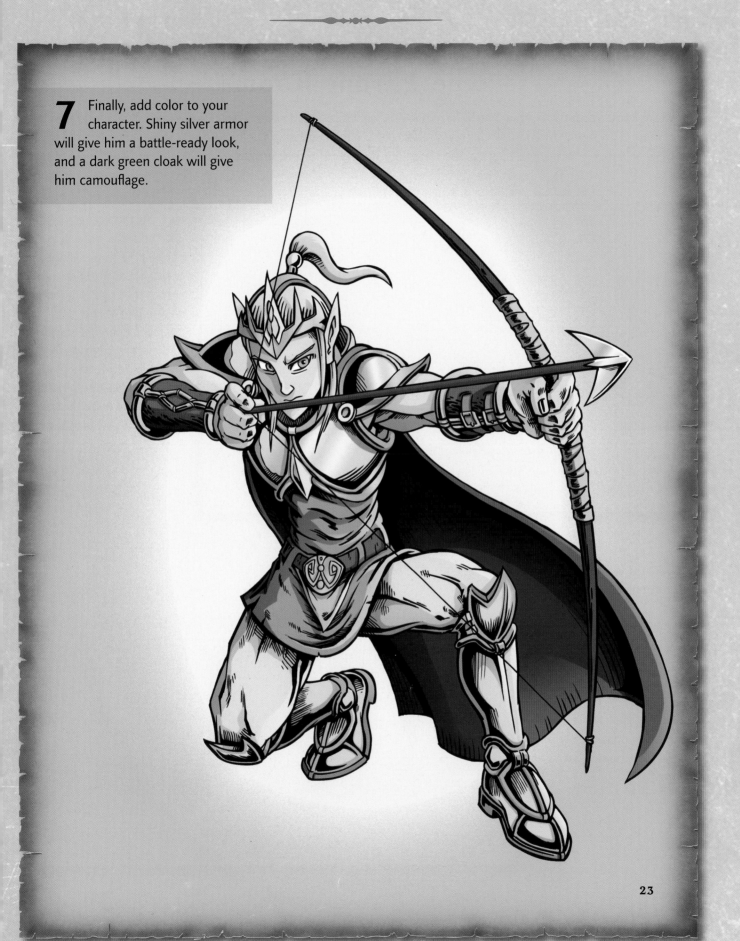

# The Throne Room

Having mastered how to draw three different royal characters, you now need to create a suitably majestic setting for them. This throne room is the chamber in which our noble heroes will hold counsel, receive homage, and plan out the campaign strategies for their armies.

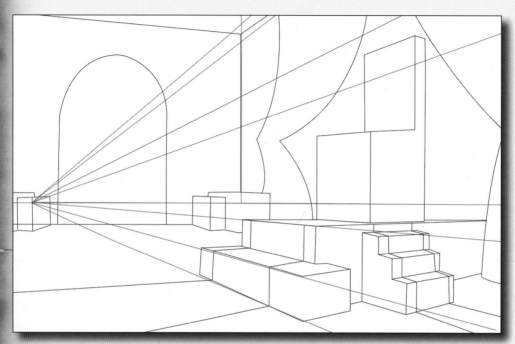

**1** As this scene is set indoors, we will not be able to see all the way to the horizon line. However, it's still a good idea to plot in lines of perspective before starting to draw the room, as those lines will decide where and how you place the objects in the room. Note the way that the lines of perspective meet at a vanishing point.

**2** Once your throne room is planned out and the basic elements have been blocked in (using those perspective lines as a guide), you can start to add some extra regal elements. Objects like statues, decorative shields, elegant drapes, and elaborate carpets will make your room fit for a king.

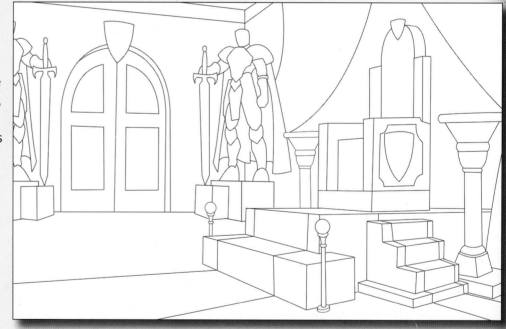

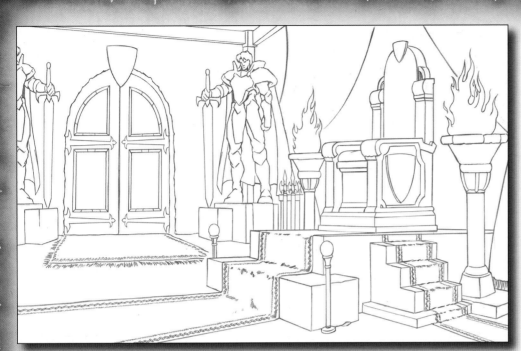

**3** Now that you have all the essential shapes in place, you can think about finer details and embellishments, like the statues' faces, the arms of the throne, the hinges and panels of the door, and the flames of the torches.

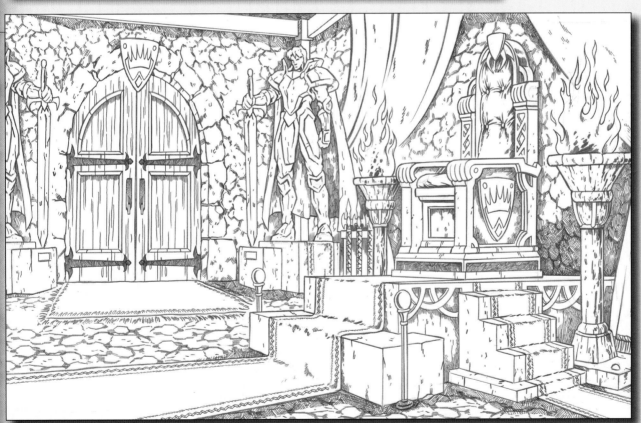

**4** When everything is in place, you can start to fully pencil the scene, concentrating on texture to bring some real life and depth to the room. The rough, rocky texture of the stone wall can be created by drawing rough, incomplete shapes in a repeating pattern. Sketchy, downward lines help to give the door a wooden appearance.

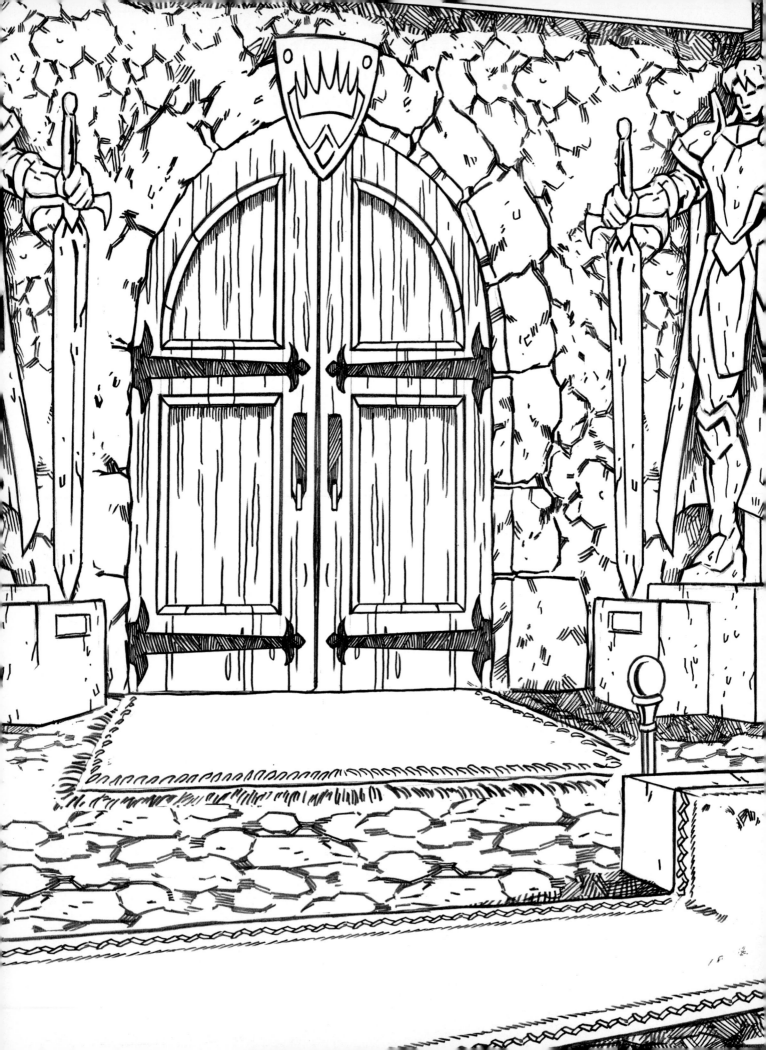

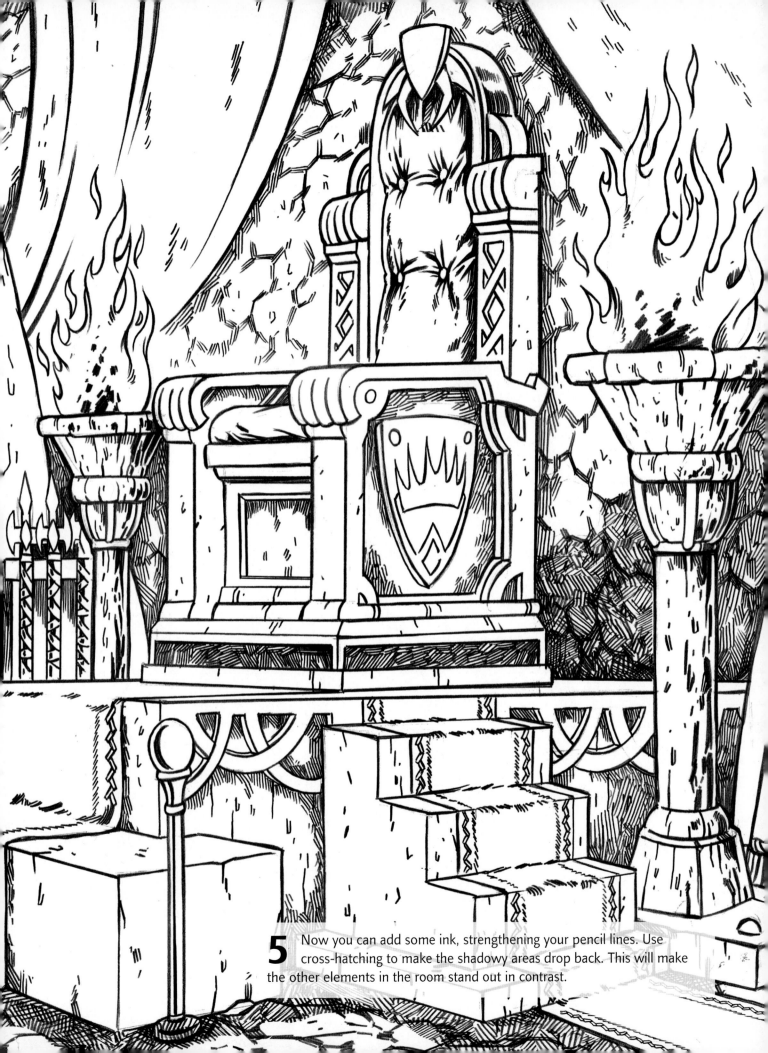

**5** Now you can add some ink, strengthening your pencil lines. Use cross-hatching to make the shadowy areas drop back. This will make the other elements in the room stand out in contrast.

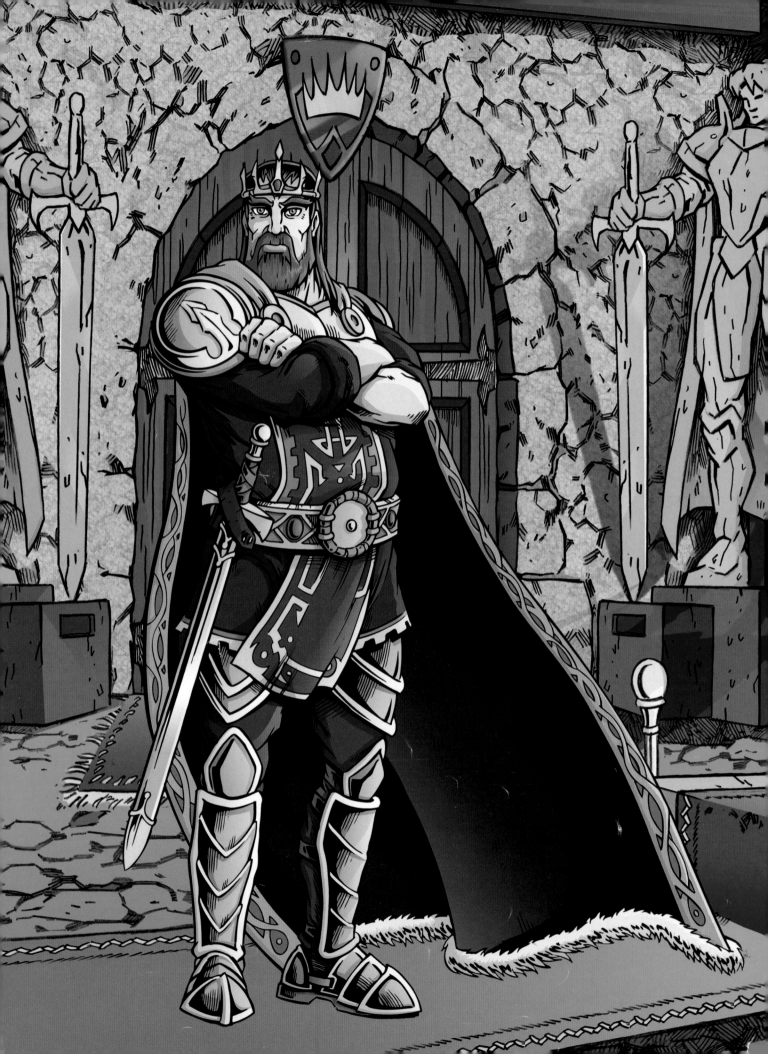

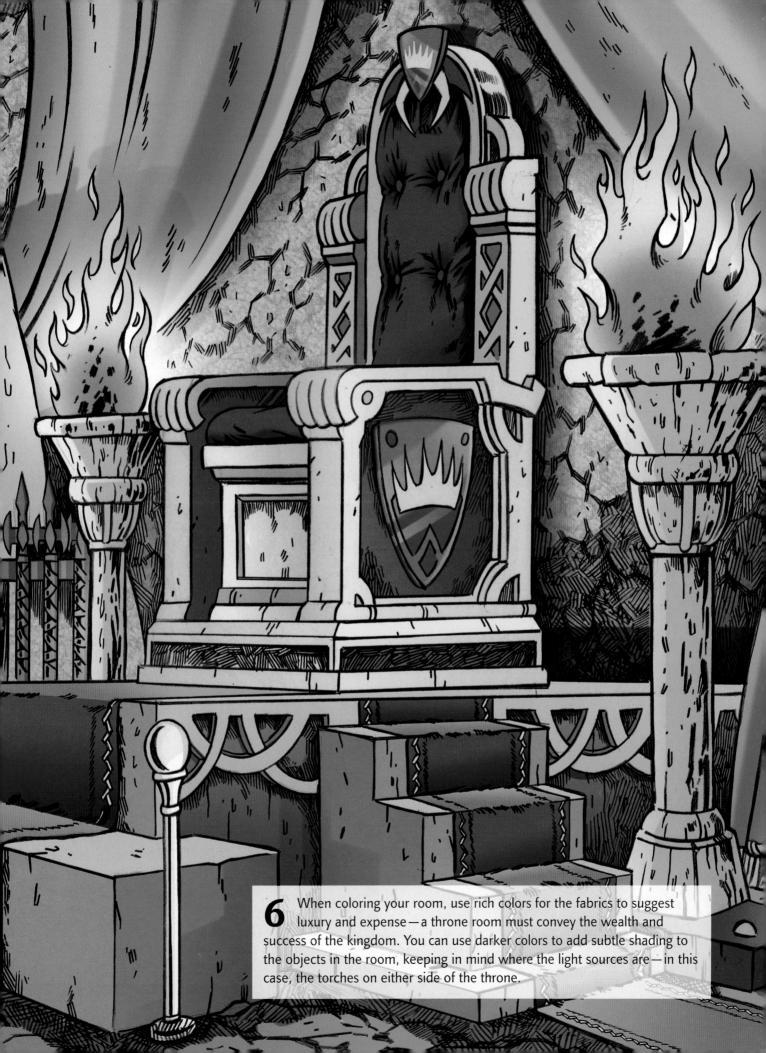

**6** When coloring your room, use rich colors for the fabrics to suggest luxury and expense—a throne room must convey the wealth and success of the kingdom. You can use darker colors to add subtle shading to the objects in the room, keeping in mind where the light sources are—in this case, the torches on either side of the throne.

# Light and Shade

**Shading gives your drawings depth and keeps them from looking flat on the page. Before you add shading or highlights, think about the shapes of the objects you have drawn. Some parts of each object will be exposed to light, while other parts will be hidden away in shadow.**

## ADDING DEPTH

Look at the two images of this goblin arm (right). When shading is added, the sleeve of the goblin's cloak suddenly looks hollow, and the beads on his arm are given a spherical, 3-D appearance.

## LIGHT SOURCE

Here we can see how the light source is casting a shadow on the drawing, and also how the goblin's beads catch the light. Use white or paler versions of your colors to add highlights.

## METAL OBJECTS

This shoulder guard is made of metal, which reflects the light. To create this effect, draw a strong shadow on the side that's farthest away from the light source.

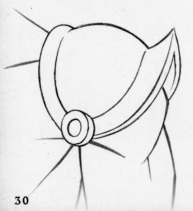

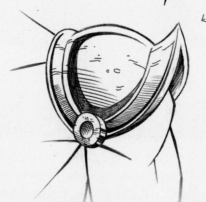

### TOP TIP !

Remember to keep your light source consistent. If the light source is coming from one direction, make sure your shadows fall on the side opposite the light source.

# Adding Finishing Touches

**Adding final details to a character's clothing, face, and body really brings them to life. They can reveal clues about your character's age, feelings, and status. Try looking at historical clothing and theatrical costumes for inspiration.**

### CLOTHING

### ACCESSORIES

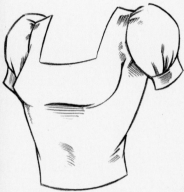

**1** On the left is a very simple top that a female character might wear. To make it look more interesting, we need to add some decoration.

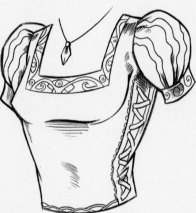

**2** Embroidered patterns around the neckline and on the sleeves add interest, and crisscross lacing is a popular period detail.

Accessories such as belts, helmets, and leather arm guards always look a bit more fantastical when decorated with symbols or jewels. Various holes, cuts, and scratches will make your armor look battle-worn.

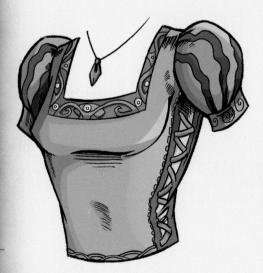

**3** When you color your character, think about their personality and status. Use nature as your inspiration for elves and fairies. Rich purples and blues give a regal impression. By contrast, brown clothes suggest poverty.

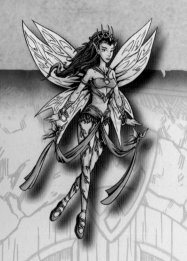

# Glossary

**counsel** formal discussion and advice

**cross-hatching** a type of shading using lines in two or more different directions

**defiant** refusing to give in

**embellishment** a decoration intended to make something more attractive

**ethereal** delicate and beautiful in a strange, otherworldly way

**highlights** the lightest colored parts of an image

**homage** a show of honor and allegiance

**majestic** impressive in a noble and beautiful way

**monarch** a king or queen

**pastel** a light, soft color

**perspective** a way of drawing that makes objects look three-dimensional

**posture** the position of someone's body

**refined** neat and elegant

**texture** the way the surface of an object looks or feels

**valor** courage in battle

**vanishing point** the place where perspective lines appear to come together into a point

# Further Reading

Beaumont, Steve. *How to Draw Magical Kings and Queens*. New York: PowerKids Press, 2007.

Cowan, Finlay. *Drawing and Painting Fantasy Figures: From the Imagination to the Page*. London: David and Charles, 2004.

Hart, Christopher. *How to Draw Fantasy Characters*. New York: Watson-Guptill, 1999.

# Index